LOTS OF
MOMS

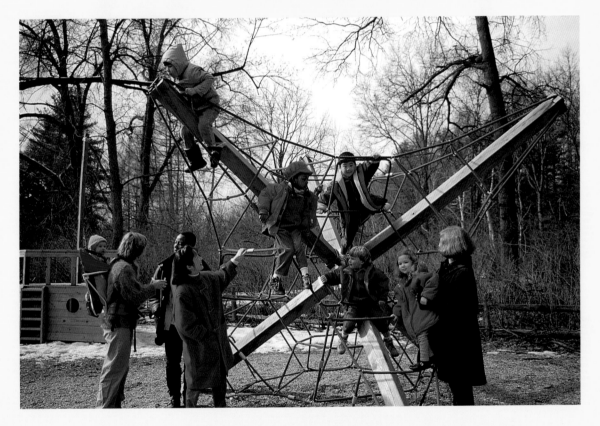

SHELLEY ROTNER *and* **SHEILA M. KELLY**
photographs by **SHELLEY ROTNER**

Dial Books for Young Readers New York

Published by Dial Books for Young Readers
A Division of Penguin Books USA Inc.
375 Hudson Street
New York, New York 10014

Printed in Hong Kong
First Edition
3 5 7 9 10 8 6 4 2

Library of Congress Cataloging in Publication Data
Rotner, Shelley.
Lots of moms / by Shelley Rotner and Sheila M. Kelly ;
photographs by Shelley Rotner.—1st ed.
p. cm.
Summary: Photographs and brief text depict a variety of mothers
engaged in different activities, with emphasis on the
similarities of mothers everywhere.
ISBN 0-8037-1891-8 (trade).—ISBN 0-8037-1892-6 (library)
1. Mothers—Pictorial works—Juvenile literature. [1. Mothers.]
I. Kelly, Sheila M. II. Title.
HQ759.R685 1996
306.874'3'0222—dc20 95–7789 CIP AC

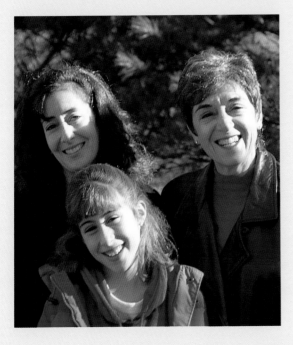

For my mom.

SHELLEY ROTNER
(left, with her mother and daughter)
is the creator of numerous highly praised
photo books for children, including
Faces, Citybook, and *Changes.* She lives
in Northampton, Massachusetts.

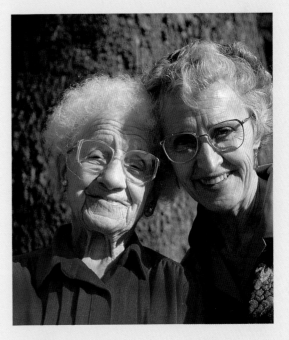

For the many
dedicated mums and
moms in my life.

SHEILA M. KELLY, ED.D.
(right, with her mother) is a child
clinical psychologist in private practice who
specializes in working with preschool
and primary-age children. She lives in
Greenfield, Massachusetts.

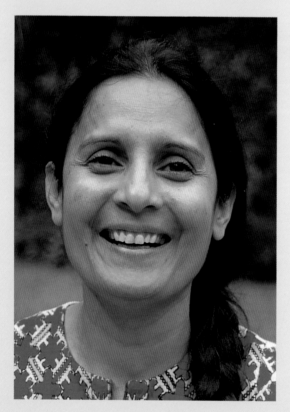
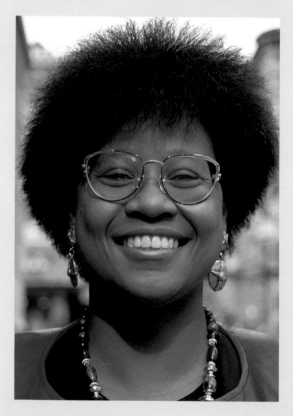

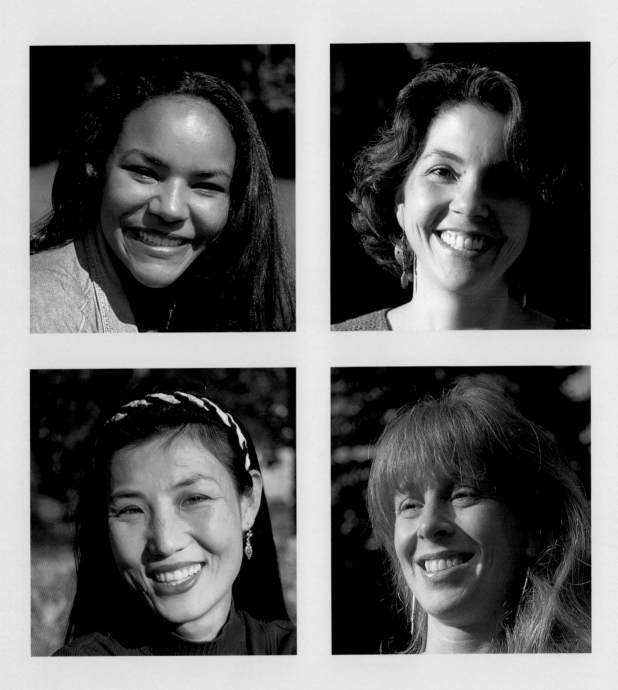

There are lots of moms everywhere.

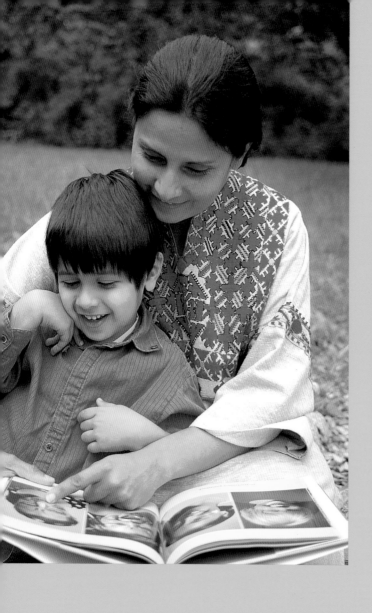

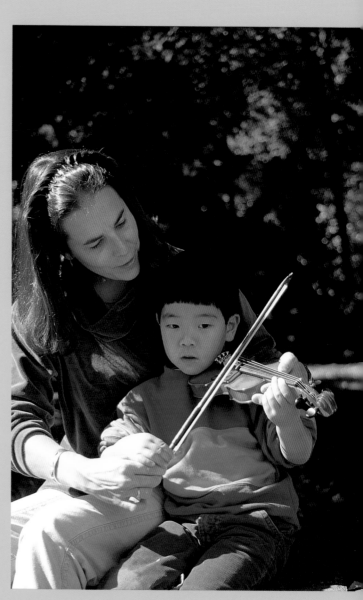

They teach you,

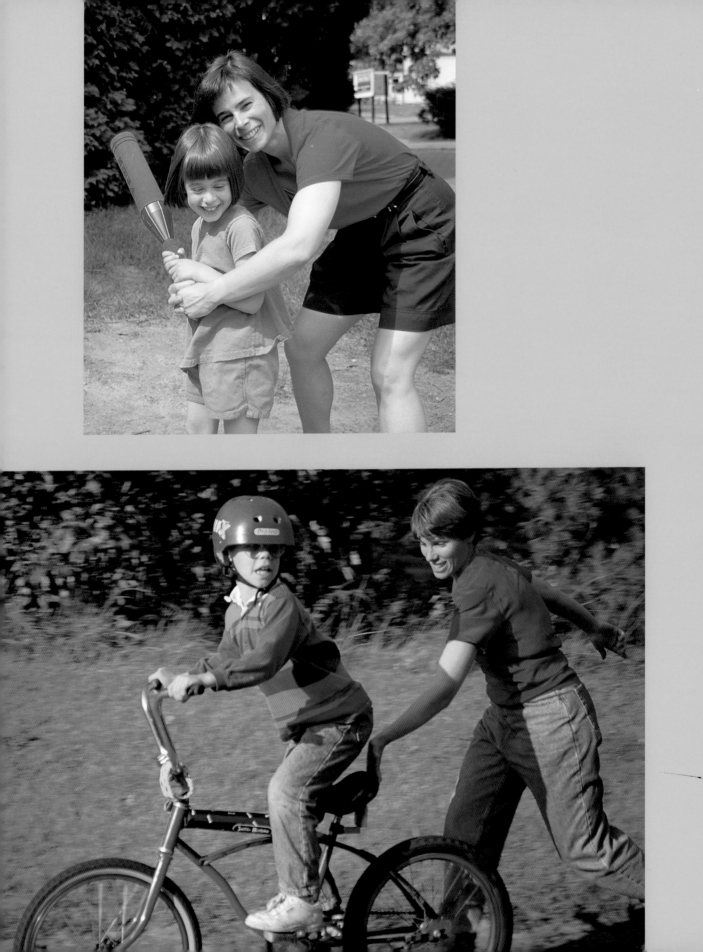

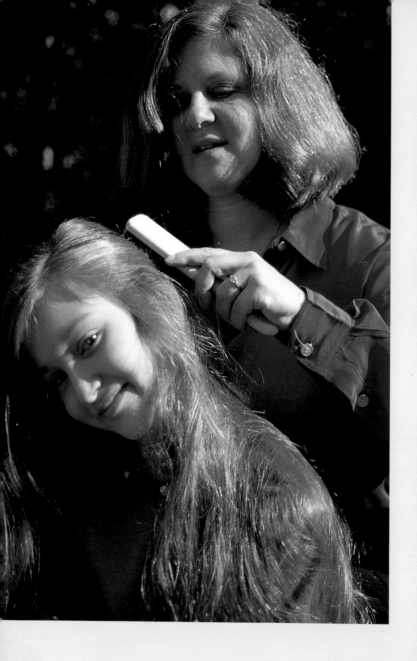

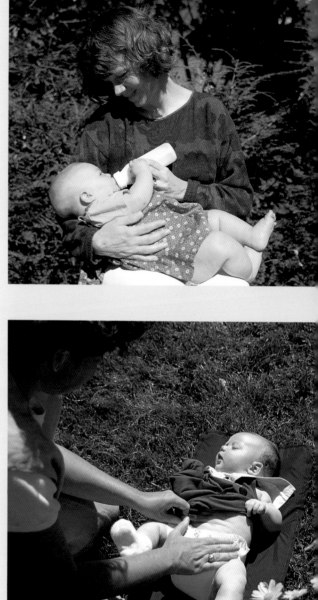

take care of you,

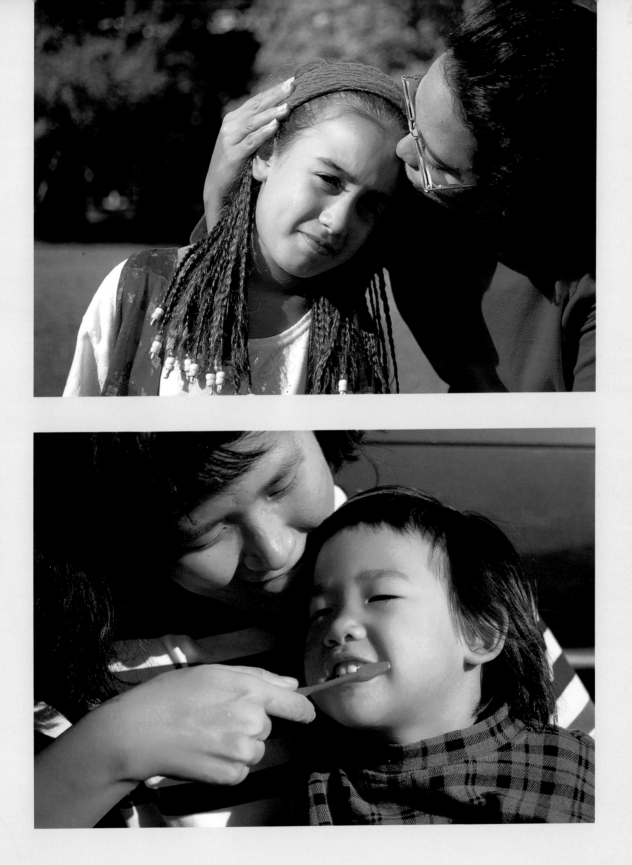

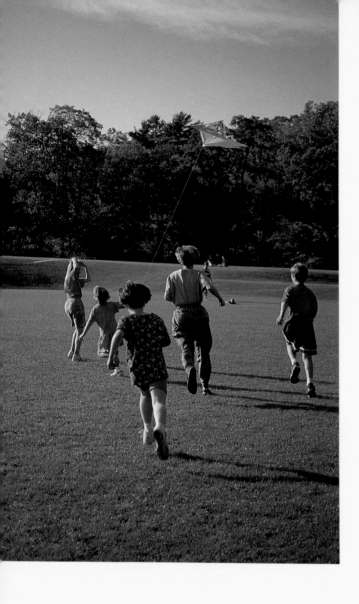

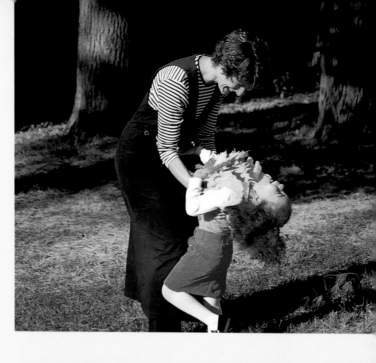

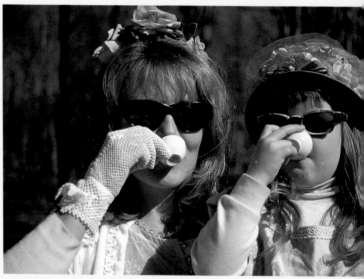

and play with you.

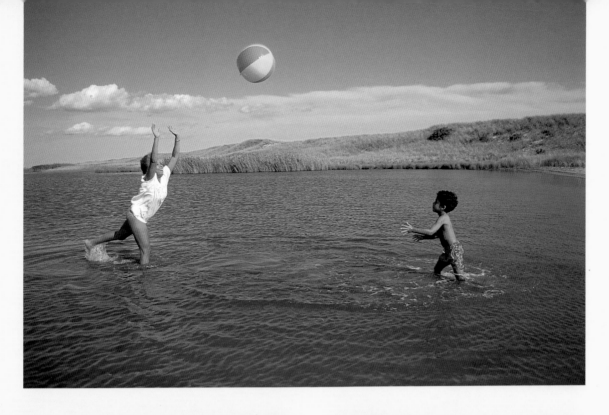

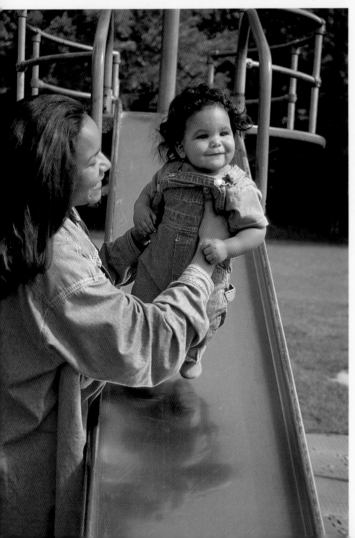

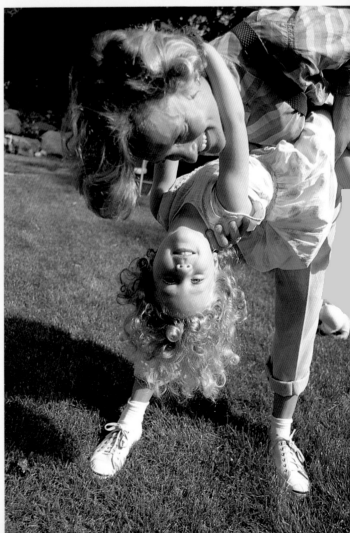

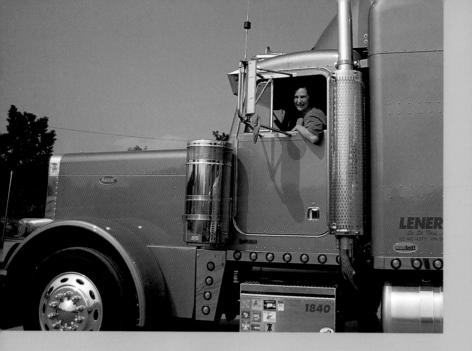

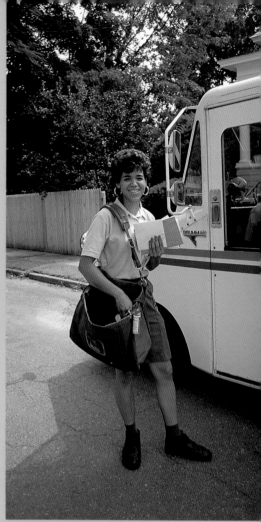

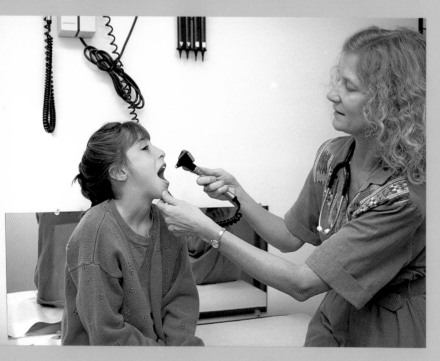

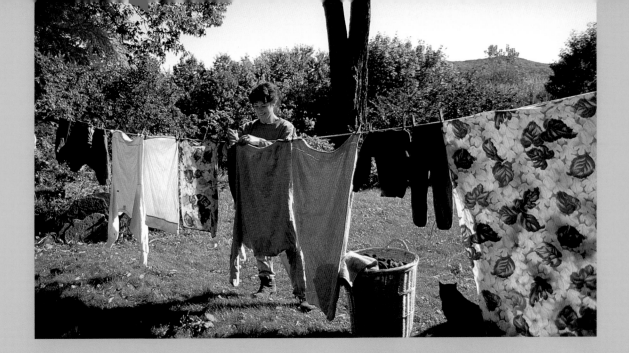

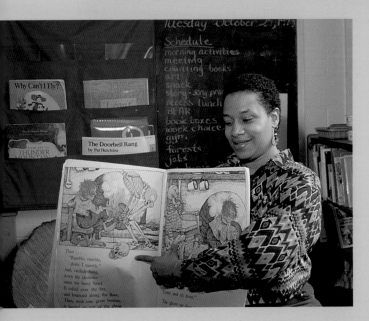

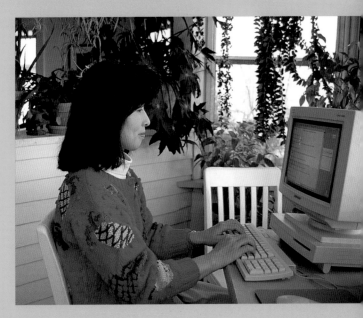

Sometimes they're busy working.

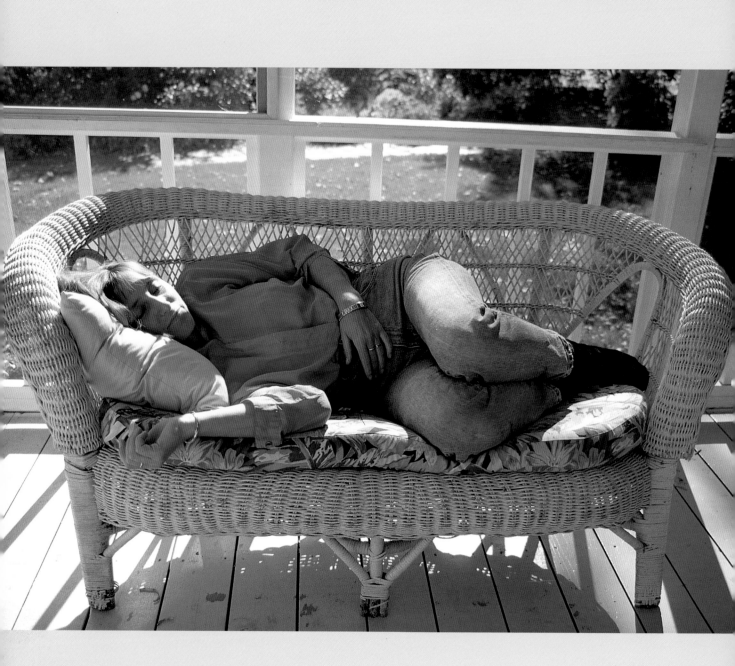

Sometimes they're tired

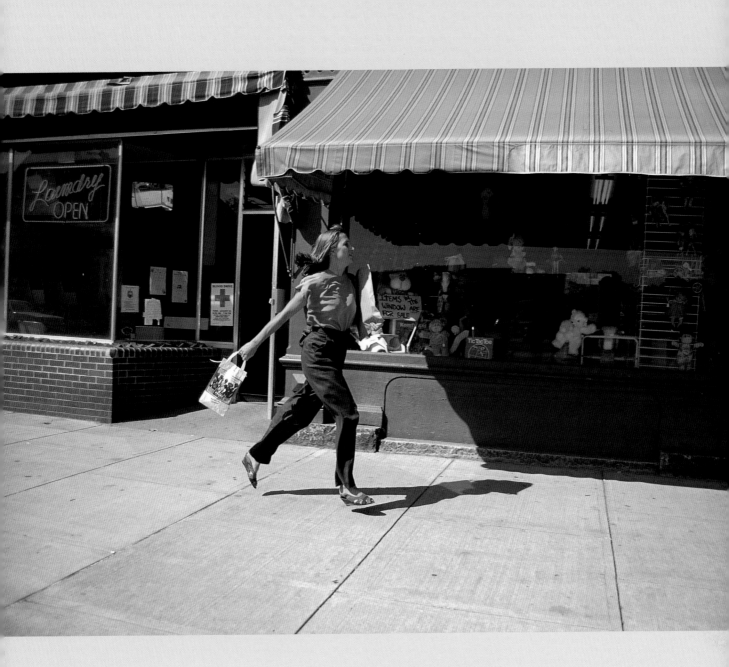

and sometimes they're in a big rush.

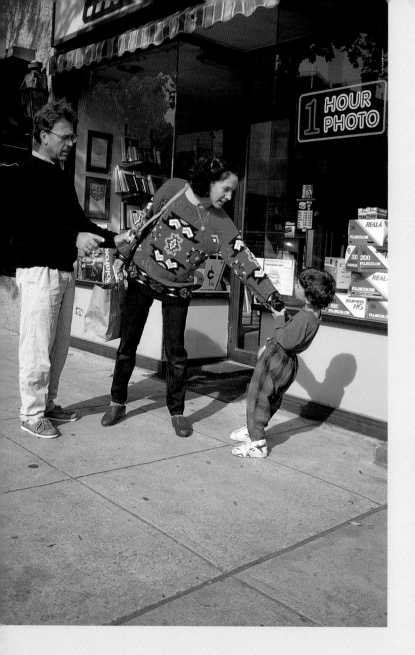

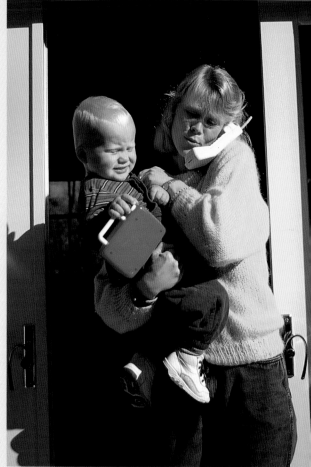

They tell you, "Wait a minute."

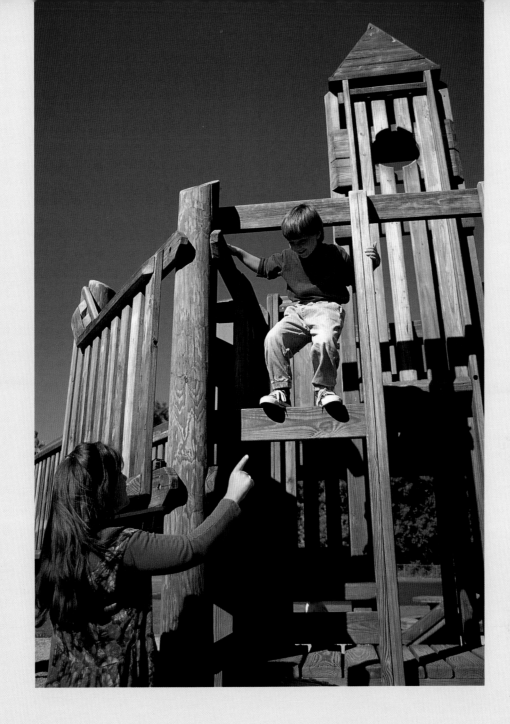

They say, "Be careful," and sometimes, "No!"

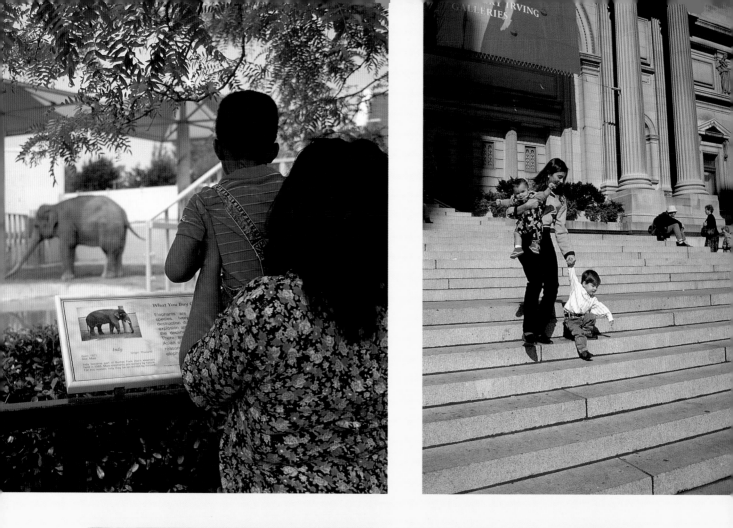
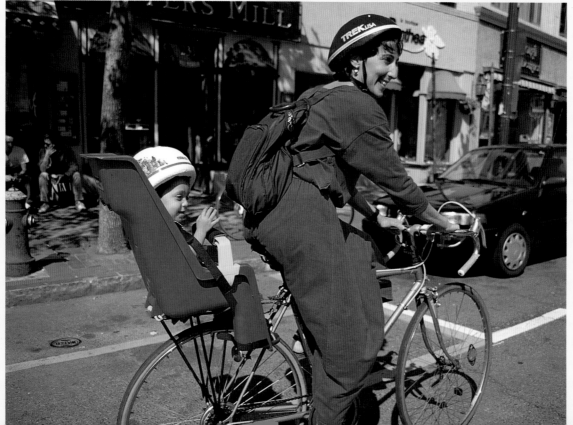

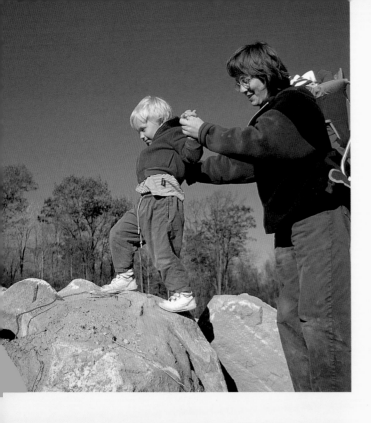

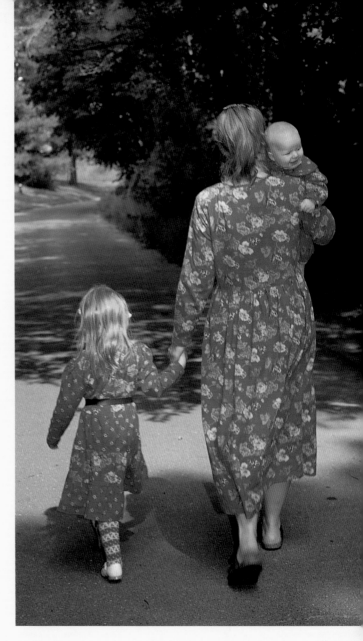

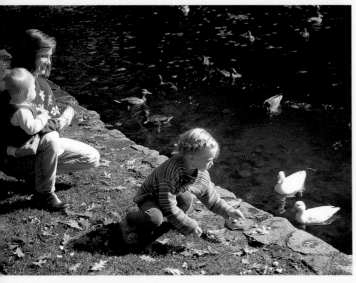

They take you to different places.

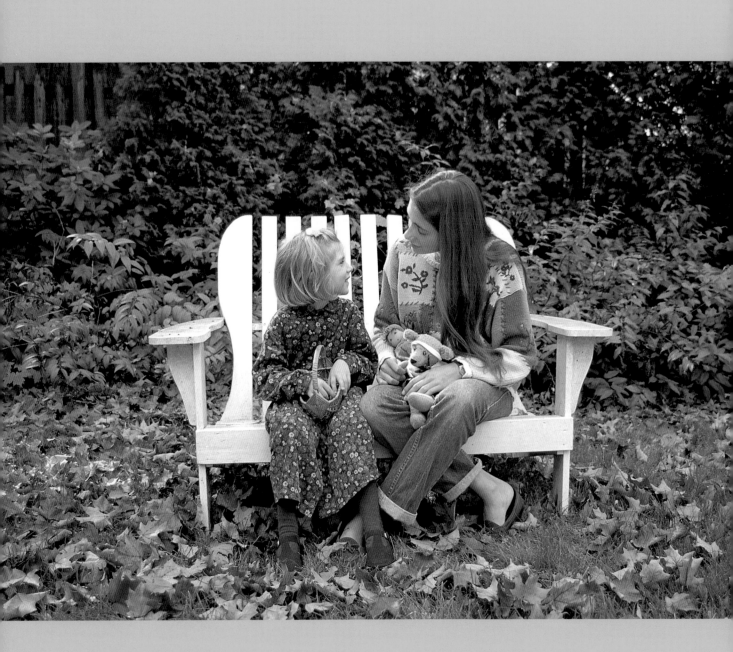

Sometimes they leave you with a sitter,

but they always come back.

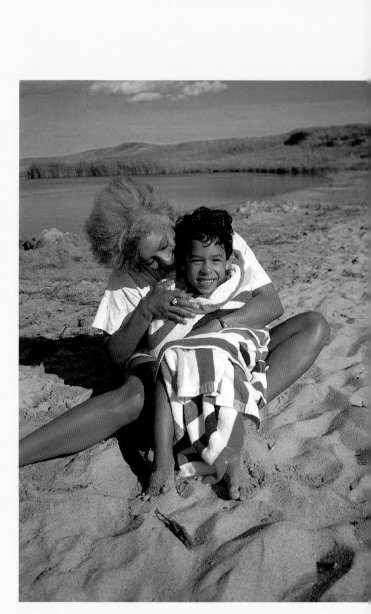

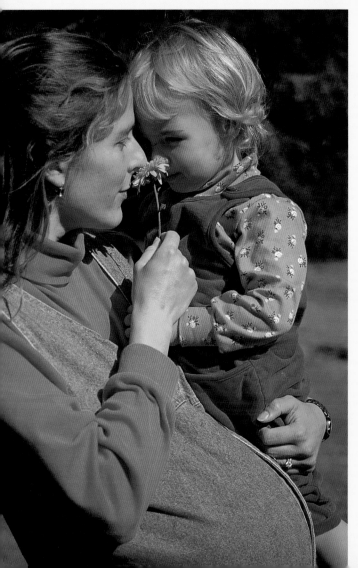

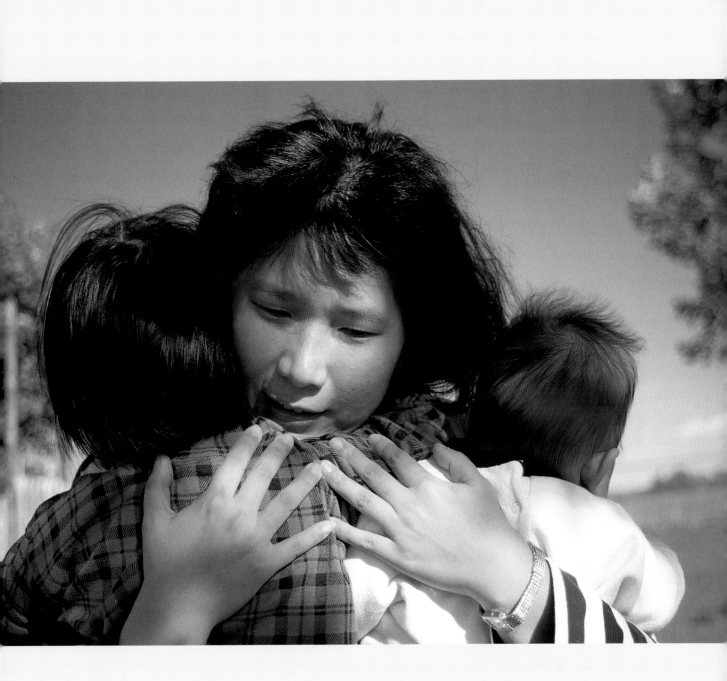

They hug you and smile and say, "I love you."

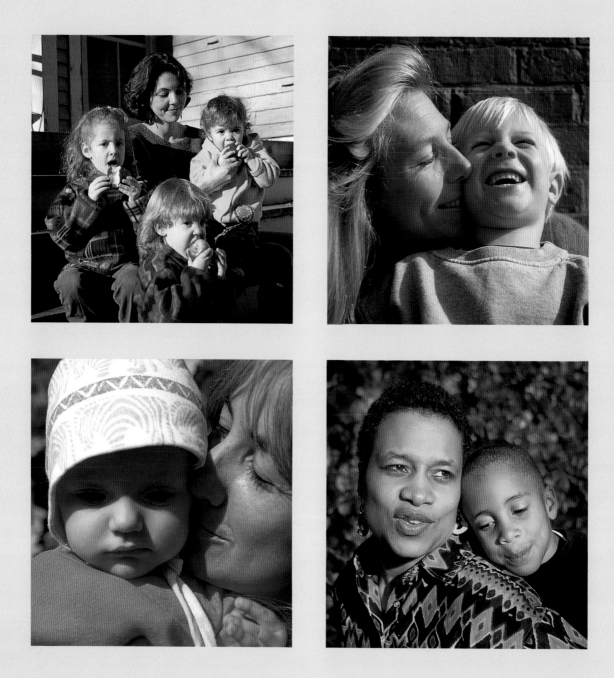

It's good there are lots of moms.